Lightroom CC
The Ultimate Beginners Guide for Digital Photographers

by James Clark

© 2016 James Clark
All Rights Reserved

Disclaimer

While all attempts have been made to verify the information provided in this book, the author does not assume any responsibility for errors, omissions, or contrary interpretations of the subject matter contained within. The information provided in this book is for educational and entertainment purposes only. The reader is responsible for his or her own actions and the author does not accept any responsibilities for any liabilities or damages, real or perceived, resulting from the use of this information.

Table of Contents

Table of Contents

Introduction

Chapter 1 – What is Lightroom CC

Chapter 2 – Adding Photos and Syncing Across Devices

Chapter 3 – Organizing with Collections and the Lightroom Catalog System

Chapter 4 – The Develop Module and Editing with Presets

Chapter 5 – Manual Editing in the Develop Module

Chapter 6 – Sharing Your Photos

Chapter 7 – Lightroom and the Creative Cloud

Conclusion

Introduction

Everyone is taking high quality digital images today; even smart phones and tablets can capture HD quality images. Just because everyone is taking quality HD images doesn't mean every image is perfect. This book will teach you how to use Lightroom CC to make every image you take perfect.

Today, photos are used for a million different reasons, for some it may be family memories and others may need pictures for products they sell on Etsy. Whatever the reason, Lightroom can help. With the right tweaks and presets, your images will express what you want them to.

If you are like most people, long tutorials and technical terms can make learning new digital skills next to impossible but it doesn't have to be that way. Each chapter covers specific steps and instructions for using Lightroom cc like a pro. This awesome software is user friendly and every step is explained in easy to understand language.

An excellent photo application like Lightroom may seem intimidating at first, but with the right instructions and a bit of confidence that learning curve can be conquered in no time. Each chapter will guide you through using all of the features available in Lightroom.

Even a beginner can learn to use Lightroom cc quickly. By the time you finish reading this book you will be able to take amazing pictures with your smartphone and share them with everyone you know.

Lightroom is very flexible and this is what makes it so fun to use. If you take photos with a dlsr Nikon or Cannon, you can import them directly to Lightroom for editing and organizing.

Images can be captured from inside the Lightroom app right on your smartphone and you can even import older images from your computer or the cloud directly to the app and this book will show you how.

When you are finished with this book, you will have all the skills you need to turn your inspiration into beautiful, professional looking photos.

Chapter 1 explains exactly what Lightroom is and what it can do, chapter 2 teaches you how to add photos and sync them on

all your devices, chapter 3 will walk you through setting up Lightroom and setting up your presets, chapter 4 is all about using the app on your mobile devices to capture images, chapter 5 will show you how to edit your images with presets or manually, and chapter 6 is all about sharing your photos.

Now it's time to get out your smartphone, turn on your tablet, and power up your computer. Those photos you have all over the place are about to get organized and polished up. Have fun with it and let your creative side take the lead.

Chapter 1 – What is Lightroom CC

Lightroom is a photo organizing and editing application created by Adobe, the creators of Photoshop and Acrobat. This photography application gives you the ability to collect, import, capture, edit, and share your photos.

All your photos can be synced to the creative cloud where they become available to all your apple or android devices.

This application software integrates seamlessly with your existing devices and computer and allows you access your photos from anywhere. This software also integrates with Adobe Photoshop to provide the best and latest image editing, compositing, and processing software available.

With Lightroom, you can take photos, edit them and share them instantly from inside the app. Lightroom is a non-destructive editing tool, all edits performed with Lightroom leave the original image untouched. If you make a mistake or do not like the edit, the original is still available.

The editing presets available for Lightroom allow you to adjust settings for presets you use most. Presets can be added to Lightroom and used in the app to bring your creative ideas into your photos without searching through a slew of settings and fixes. You can learn to add presets and set these presets within Lightroom to make them available quickly.

Lightroom gives you the ability to work on your photos from all of your devices. You can sync them and open your work on one device, work on it on another device and finish up and share on your computer. Lightroom is fast and can speed up your photo editing, making the editing you do 10 times faster than it was before.

Nothing is more frustrating than purchasing software or an application then in a few years, having to purchase a newer version. With Lightroom that is not a problem. Adobe Creative Cloud is a service that provides photographers with the best software apps and access to updates and new apps as they are produced.

With Creative Cloud, all you should worry about is taking great pictures, the tools you need are all in one place and up to date.

Learning to use Lightroom is easy and fun. You will be capturing, editing, and sharing your photos quickly and professionally in no time. Lightroom can add mood, character, and artistic flair to every photo you take and then keep them all organized and available forever.

This may be the last photo editing and organizing software you will ever need.

Chapter 2 – Adding Photos and Syncing Across Devices

Lightroom has several "modules" or tabs at the top right hand corner of the app on your computer. One of those tabs is "Library", library is the tab where you will add photos so they can be accessed in Lightroom.

The following steps are for importing stored photos from your computer or digital camera to the library of your Lightroom cc application.

- Click the **Library tab/module** in the upper right hand corner

- Click the **Import button** located at the bottom of the window in the left-hand corner

- In the **Source panel** on the left-hand side of the import window, navigate to the file or drive your photos are stored in

- In the **Viewing pane**, check off all the images you want to import or copy

- At the center of the screen, at the top, over the images click **Add** to import from your computer or click **Copy** to import from a digital camera memory card

- You will have **Options** before importing so you can choose the destination folder where Lightroom will store your photos

- Click **Import** on the bottom right of the screen to import all your checked photos, when this is complete you will be returned to the Library

Using the Library Module:

When you open Lightroom cc you will notice tabs at the top of the page, these tabs open individual modules in Lightroom. The Library Module is where options for importing and adding photos can be found. Click the Library Module to open the Library.

The next step is to click the import button; this button will open the source panel on the left-hand side of the import window. The source panel allows you to navigate to the folder, or drive that contains photos on your computer. When you navigate to the folder or drive, they will appear in the viewing pane.

When importing photos from your computer you must click the **add** button at the top center of the screen. When importing photos from a camera you must click the **copy** button at the center top of the screen. The **move** and **add** buttons are not clickable during import from a camera.

Destination options are available on the right-hand side of the screen when importing from a camera. These options give you control over where the images will be stored, how to organize imported photos, and the date format to be used. The destination options are only available when importing from a camera.

The viewing pane in the center of the screen will display the photos on your computer or digital camera memory card. You now have the option to choose which photos you want to import. Put a check mark next the images you want.

On the right-hand side of the screen there are options for importing. These options are listed under **file handling**. Under file handling you can choose to import without deleting

the photos from the source, build smart previews, make a second copy or add to a specific collection.

Another group of options available during import is located under **apply during import**. Under apply during import you have the option to apply several different presets and other image settings to the photos as they are imported and add metadata and or keywords.

After importing, adding or copying, Lightroom will switch back to the Library Module where you can view the images you just imported. Now you can view your imported and copied photos to the Library in Lightroom from any synced device. Now it is time to sync your devices with Lightroom.

Syncing your Devices:

Once all your photos are in the Library Module, you can view them and work with them on any Apple or Android device. To begin syncing your devices you must download the Lightroom cc app for your Android or Apple devices. You will sign in using your Adobe ID, once you are signed in you are synced with your ID.

Anything you do in the Lightroom app on your computer or the Lightroom mobile app will be synced seamlessly on all your devices. Check the box Sync with Lightroom Mobile to sync with all devices.

The Library Module in Lightroom on your computer will display all the photos you take using your other devices. Lightroom mobile also gives you the capability to use Lightroom for capturing photos using your smartphone directly into your Library.

Chapter 3 – Organizing with Collections and the Lightroom Catalog System

The easiest way to organize and make your photos accessible to all devices is to create collections. A collection is a group of photos you keep together, like an album. You can add to collections when you import or after importing in the Library Module. In the Library Module, the Collections tab is in the upper right hand corner under File Handling.

To add to a collection or create collections click the + button under the **New Collection** in the Library Module and choose **Create Collection**.

Make sure the box "include selected photos" is not checked, you will add them yourself, and check the box, "sync with Lightroom on mobile", this will make the collection available to synced devices then click create.

Now you are going to add some photos to the collection you just created. You are going to drag the photo from the select

frame to the collection you created on the left under Collections. You can drag multiple photos to the same collection by selecting them from the viewing area.

It's as easy as that, now that you have your photos organized and synced, you can work on them from any device. You can now edit the photos in your collections, add to the photos in your collections, and create as many collections as you need to keep them organized.

It is always a good idea to choose titles for your collections that describe the type of images you have chosen for that group of pictures. Once you have created a bunch of collections it will be easier to find the exact pictures you want if the titles reflect the photos in the collection.

Collections are the best way to organize and share. Collections make it easy to upload to Facebook, Flickr, or your own web gallery. Keeping similar images together also makes it easy to create a portfolio of your work when you need to. Finding vacation photos from last year is much easier if they are all in one place with the right title.

Lightroom Catalog File Management

Basic organization using collections is only the beginning of managing your files with Lightroom. In this section, you will learn about file management in Lightroom.

This information will be important as you become more and more proficient at using Lightroom. Understanding Lightroom file management ensures that your images are easy to locate, easy to edit, and most of all still available in the original state.

Once you make changes to your images through editing, the original image should still be available. Lightroom allows you to maintain the original image without any changes, and still save the new, edited version. This is not rocket science, but it is pretty in depth.

Take your time with this section, it will make a big difference in your experience using Lightroom software.

Lightroom uses a catalog system to save and keep track of your photos. The catalog is the main folder where your photos are stored; your collections are a file in the catalog.

Understanding the Lightroom catalog work-flow handles files will help you keep the system working smoothly.

There are two main advantages to the Lightroom catalog file system. The Lightroom catalog will always have the original raw file of your photos so the editing you do is completely non-destructive to the original photo and the photo's you take can be stored anywhere.

These two advantages take the stress out of losing your original photo during editing, and running out of room on your hard drive.

The Lightroom catalog does not work the same way as a file browser. The catalog keeps a record of every photo you import, by recording the location of the photo, the metadata associated with your photo, and any instructions created for how the photo should be processed.

In this way, the catalog can maintain the original unedited photo because the information created during editing is stored separately from the original photo. The catalog also gives you

access to your photos even if the Lightroom software is installed on a different hard drive.

Although you can create multiple catalogs, merge them, and combine them; it is better to keep all your work in one catalog. The reason it is better to keep all your photos in one catalog is because this will ensure the links created between your photos, metadata, and location will not become confused or break. Lightroom works quicker and smoother if all the photos are stored in one catalog. There is no limit to the number of photos you can save in one catalog.

The best and easiest way to maintain smooth workflow using Lightroom catalogs is to decide where you are going to store the Lightroom catalog, chose the path and the folder you will save the catalog to, and whether it will be stored on your computer's hard drive or an external hard drive.

If you have a large hard drive with enough space for the photos you already have and the new ones you will take over time, then the hard drive on your computer is a good choice. If you have many photos and plan to take many more, it may be best to use an external hard drive for your photos. Remember, you

can store your catalog on an external hard drive and still access it on your computer.

Once you have decided where to keep your catalog, you can start importing your photos. If you decide to change the location of your catalog, or rename anything, make sure you do it from within the Lightroom program itself. This will ensure that the links to your photos and metadata will always work properly.

How to Create a Catalog

When a catalog is created, a folder with the same name is created too. To create a catalog, click on choose file, then under choose file, click, new catalog. Give the folder a name and specify a location, then save in Windows or create in Mac. Once you save or create, the library module will launch so you can import photos

How to Open a Catalog

If you have more than one catalog, Lightroom will close and start up again each time you want to change catalogs. To open

a catalog, click choose file, then open catalog, in the box give the catalog file then click open.

Another way to open a catalog is to choose a catalog, click file, then open recent menu. If you are switching between catalogs, you will be prompted to close Lightroom and start it up again.

Copy, Move, or Export a Catalog

Always back up your work before moving or copying a catalog, this will ensure you do not lose your work. To move or copy a catalog on a Windows computer, click edit, then catalog settings, to copy on a Mac computer, click Lightroom, then catalog settings.

In the General panel, click Show, then click on the catalog in Explorer, if using a Mac computer, you will click on Finder instead of Explorer then close Lightroom.

Using Explorer or Finder, locate the catalog. Ircat, previews. Irdata, and if available, the preview. Irdata, and copy and move these files to the new location. Now double click on the catalog. Ircat file and the catalog will open Lightroom.

To take photos from the catalog and create a new catalog you can export them.

To export a catalog, select the photos for export, click file, then export as a catalog, choose a name and location for the new catalog, decide on whether to export both the negative and the preview files, and if you are using Windows click save, if you are on a Mac, click export catalog.

To view this new catalog, you must open it in Lightroom.

Delete or Change the Default Catalog

When you delete a catalog, only the work or editing you have done in Lightroom is deleted, the original photos are not deleted. Using Explorer or Finder on a Mac, find the folder on your computer that has the catalog file, then drag it to the recycling bin or trash.

The default catalog is the catalog that is opened when Lightroom starts up. You can change the catalog that is opened on start up in a few simple steps. Click edit then click preferences, if you are using a Mac, click Lightroom, then

preferences, under the general tab, choose from the list of options for startup.

You can load the most recent catalog as a default, choose a catalog from a list for startup, or request a prompt for a choice at startup.

Customize and Optimize a Catalog

Customizing your catalog is as easy as giving specific instructions to the Lightroom catalogs at start up. To give these instructions, click edit, then catalog settings, and in the general tab choose from the following:

- Information – This provides information about file location, file name and the date the catalog was created. From here you can click show when using Windows to show the catalog file in Explorer or find when using Mac.

- Backup – This option allows you to decide when and how often you back up your catalog.

Under the **File Handling** tab, you can specify some of the following:

- Preview quality – this tab specifies how the thumbnails appear, either small, medium, or large
- Standard preview size – this specifies the preview size, choose a size that is larger or the same as your computer's resolution
- Preview cache - this specifies how Lightroom renders previews
- Automatically discard 1:1 previews – Lightroom renders high quality previews, deleting them periodically will speed up the program because these previews are not slowing down the program because of the large files in the catalog preview file
- Smart Previews – this tab tells you the amount of disk space being utilized by smart previews
- Import sequence numbers– this tab allows you to provide the starting number for imported number sequences, and the number for photo sequences

Under the **Metadata** tab, you can choose your preferences for the following:

- Suggestions from recently entered values – you can "deselect" or "clear" this suggestion list, the list helps by offering suggestions when you type metadata entries
- Enable reverse geocoding of GPS coordinates to provide address suggestions – enable or disable to allow or stop Lightroom from sending geo-location information to Google to obtain the address and save it to the IPTC data (location metadata)
- Automatically write changes into XMP – when this is selected, metadata changes are saved to the XMP sidecar files, and this will ensure that the changes are shared with other applications
- Include develop settings in metadata inside JPEG, TIFF, PNG, and PSD files – select or deselect this option, when this options is selected, Lightroom will

include the develop module information in the XMP metadata of JPEG, TIFF, PNG, and PSD

- Export reverse geocoding suggestions whenever address fields are empty – select this option to include Google suggested IPTC metadata in exported photos

- Write date or time changes into proprietary raw files – select this option if you want Lightroom to write a new date and time to proprietary raw files when you use the Edit Capture Time command to change your photo's time and capture metadata

Optimizing your catalog is used when the program begins to run slower than normal. Editing and importing large numbers of photos is one reason the program may run slow.

You can optimize your catalog and this will speed up Lightroom. To optimize: Find the choose file tab and click on Optimize catalog

Chapter 4 – The Develop Module and Editing with Presets

When you open the develop module you will notice the large rectangle in the center, and around the sides are tools for editing your photo. Each of the items around the center rectangle contain editing tools, below is a list of the tools shown on the develop module page.

- **Presets** are located on the left-hand side along with History, Snapshots, and the collections panel
- The toolbar panel is located at the bottom of the develop module
- **The Histogram** panel is located at the top right corner of the develop module
- **Photo Information** is located on the histogram panel
- **Smart View** is located on the histogram panel under the photo information
- A **Tool Strip** is located beneath the smart view panel on the histogram panel

There are many tools in the develop modules, you will eventually learn all of them. There is no rush, you will learn as you go along. The following tools are available in the develop module:

Copy Settings – Copy settings are available in the before and after view. These options giving you the option to copy and paste settings to the before and after views

Copy and Paste- These options are available under the left-hand panels; these options will let you cut and paste settings to the item selected

Loupe View – Loop view allows you to rotate between photos, this option is available in the Library mode too

Before and After Views – This option allows you to work with and between two separate views of your photo

Previous Synch and Auto synch – This control option gives you the ability to apply previous settings to the new photo, there are many command prompts that all do something different regarding the photo you are working on, or the photos in the photo tray

Hand Tool/Zoom tool – The hand tool/zoom option allows you to zoom your image in and out, and the hand tool allows you to "grab" the picture and move it around the screen

Targeted Adjustment – This option lets you adjust targeted colors and tone in your image by using the sliders provided

White Balance Selectors – The white balance selectors provide you with tools to adjust the white balance in your images

Basic Presets

A basic set of presets is provided by the Lightroom software. You can apply these preset changes and save them to you image or you can apply these changes and continue to tweak the sliders and other tools to create a personalized preset.

If you tweak the preset save it with a different name so it does not get confused with the original preset, you started with.

Lightroom can be customized to personalize your photos and organize when you import them into your Library. Each preset is explained here so you can set up Lightroom the way you want, or you can change the presets for each individual photo. Presets give your photos a unique personal touch.

Presets do the fine tuning for you. When you choose a preset, you are choosing a select group of changes that will be applied

to the photograph. You can do the changes manually too, but for many beginners, the best way to learn how you can fine tune and achieve a certain look for an image is to use presets.

When you first begin editing your own photos and using presets, Lightroom has a feature that will help you gain experience and give you an eye for the changes.

The photo you are working on can be split down the middle, one side shows the original photo unedited, the other side shows the edited version.

As a beginner, you will benefit from seeing the changes in front of you and as you gain experience you will be able to use these tools manually as well.

Many photographers complain about presets, do not let this concern you, as a beginner, presets are teaching tools. The basic presets in Development Settings will make the changes for you per the preset you have chosen.

The best way to learn is to choose a photo and apply presets. Try and use every preset, one at a time and take note of the changes it creates.

How to View Before and After Images for Comparison

While you are in the develop module, you can view the image you are working on. This will allow you to visually compare the changes made to the image by the tools and presets you have applied, one image is the original and the other is the image you have tweaked.

You can use this setting as you adjust and tweak the photo, the after view will change a you work, the before view will remain the same. The zoom and the pan are in synch in both the before and after views.

To view your photo one at a time as before and then after, click the backslash key "\" on the computer. To show before and after views of the photo together click the before and after button on the toolbar then toggle through the view styles, or you can even choose an option from the pop up menu.

Here is a list of the different views you can achieve with the before and after options:

- **Left and right** – This option shows both before and

 after images full size, side by side

- **Left and right split** – This option shows both before and after images split in half and side by side

- **Top and bottom** – This option show both before and after images full size and one on top of the other

- **Top and bottom split** – This option shows both the before and after images split in half and one on top of the other

Presets are available in a few different modules in Lightroom. Presets are available in the **Import Module**, **Library Module**, **Develop Module**, **Map Module**, **Book Module**, the **Export Module**, the **Slide Show Module**, **Print Module**, and the **Web Module**.

Learning the presets for each module will provide you with the experience you need to take control of the artistic and technical side so you can manually edit your photos like a pro.

The following is a list of basic presets are available in the **Develop Module**:

- Black and White Filter Presets

- Black and White Presets

- Black and White Toned Presets

- Color Presets

- Effect Presets

- General Presets

- Video Presets

Each preset choice opens a new list of presets for that group. These presets are available for use during import and during editing. As you use Lightroom you will learn which presets you like and when to use them. You will even learn how to tweak the basic presets and save them as a new preset.

The basic preset category list in the Lightroom Develop Module has more presets under each preset category. Try out these presets so you can see for yourself how each one affects your photos.

As you try them out and learn about the changes each preset makes, you can try moving the sliders to adjust even more.

Using Basic and Custom Presets

Once you create a preset using the develop module it will stay there until it is deleted.

It will also show up in the list of develop settings during photo import. Basic presets move the sliders and make the adjustments to your photo, a preset is a finished photo "look", there is no need to do anything else to your photo, and you can even apply the same preset to a whole batch of imported photos.

When you create, and presets you need to organize a develop preset folder or folders. Follow these steps to organize and preserve your customized presets:

- If you are using a window based computer, you will right-click, if you are using a Mac computer you will control-click where you want the folder to be then choose new folder
- Create a name for your new presets folder and click ok

- Now you can click and drag the new template to the folder or if you use windows, you can cut and then paste the template to the new folder

How to create a new develop preset

Remember, any preset you create is based on the new photo, the current settings of the photo. If you have tweaked the skin tone, or anything else in the photo, the preset you create might not look good on every photo you try it on.

Follow these steps to create your own develop preset:

- From the develop module you will click Create New Preset on the presets panel at the top, or you can click develop and then new preset

- Now you can tick the box to select all presets, or tick the box Check None and this will remove all presets, at this point, you can click any of the edits you want to save as

a preset and once you are finished the you preset will be added to the presets panel in the chosen folder

You can even go back and update or change a develop preset by selecting a user preset and then choosing settings to modify the preset the way you want it. Once you are finished right click or control click the preset in the preset panel and then click update with current setting. Then you must choose the settings and click update.

To delete a custom preset you must first understand that you cannot delete a preset that came included with the Lightroom software, only custom presets can be deleted.

To delete a custom preset, right click or control click a preset from the panel then click delete. You must use this step to delete, if you use the delete key on your computer the current photo will be deleted.

Saving and Storing Custom Presets

Lightroom stores user presets in a folder that is inside the Lightroom folder. If you wish to save or store your presets inside a folder with the catalog, just find the presets panel of

the preferences dialog box and check off store presets with catalog.

If you want to see the location where these presets are stored, right click or control click the presets panel and the select the show in explorer for Windows and show in finder for Mac. All preset templates use an lrtemplate extenstion.

Importing and exporting a preset is a breeze. When you want to export your preset to a different computer or share it, you can just; right click or control click on the preset and click export, then put the name of the preset template and then save.

If you want to import a preset just; right click or control click where you want to preset to be then click import, then double click the preset template.

Downloadable Presets

Lightroom allows for downloadable presets, a downloadable preset is a preset created by Adobe or by those who create their own presets. Downloadable presets can be downloaded directly into the Lightroom program. Once the presets are downloaded and installed they become available to Lightroom to use for editing.

There are many reasons why photographers used downloadable presets. The changes and adjustments available in a preset may not be exactly what the photographer had in mind. The ability to search for and find a preset that does exactly what the photographer wants is a big deal.

These downloads are known as develop presets. Many developers create awesome presets and these presets are sold for use with Lightroom.

There are many basic presets that come with the original Lightroom software, but develop presets offer a wider range of artistic flair and style than the ones that come with the package.

Adobe itself has links to develop presets created by developers and others, and there are many pay for preset sites available online too. The best advice is to download and install the free presets available at Adobe Lightroom and play with them a bit before you begin purchasing them.

Add ins and Lightroom presets give you an awesome amount of creativity and inspiration. Try them out, and if you don't like them, you can remove them without a problem.

Chapter 5 – Manual Editing in the Develop Module

The **Develop Module** is where you edit your photos. The develop module has everything you need to adjust your photos without degrading the quality of your original.

Before you begin editing you will need click the Develop Module at the top of the page. Once you are in the Develop Module, you can pick the image you want to edit.

On the left side of the Develop Module you will find what you need to select an image or images, preview them during editing and apply global presets. Navigator, Presets, Snapshots, History, and Collections panels for previewing, selecting, and saving your changes are all located on the left-hand side of the center pane.

The center of the Develop Module is where you can view your image or images as you edit. The center pane is both the viewing and working area, beneath this pane are function tools, these tools provide you with access to functions such as soft preview and toggling between images.

On the right-hand side of the center pane are tools for adjusting global and local adjustments. The right-side toolbar allows you to see before and after images, zoom, and play a slide show.

Each panel in the Develop Module has different editing functions:

- Histogram measures color tones and adjusts color tone
- The basic panel of main tools is for adjusting the white balance, color saturation, and tonal scale
- The tone curve and HSL/Color/B&W panels have tools for fine tuning color and tone
- The split toning panel allows you to color monochrome images, and add special effects with color
- The detail panel is for noise reduction and adjusting sharpness
- Lens correction panel allows you to correct problems such as lens vignette and chromatic aberration

- The effects panel lets you apply a vignette, film grain, adjust haze and fog in a photo

- The camera calibration panel lets you adjust the default calibration on your camera

- Find the tone on the basic panel and use auto to set the overall tone using Lightroom then tweak it from there

- Sharpen and reduce noise

- Correct flaws

- Adjust for artistic effect

- Apply your adjustments to other photos

Making global adjustments to color

- **Adjust global image tonal scale** - Global adjustments are adjustments that affect the entire image. You will use the tonal scale sliders on the basic panel, pay attention to the ends of the histogram as you move the sliders.
If you are uncomfortable doing it this way, try using shadow and highlight. Under tone in the basic panel, you can auto set the overall tonal scale, this allows

Lightroom set the settings to maximize the scale to minimize the highlights and shadow clipping

- **Adjust Tone Controls**
 - **Exposure** – this setting is for overall brightness. To adjust slide the slider until you like the look of the photo. Exposure value is equivalent to aperture values on a camera. As you slide the slider, the number - +2.00 is the same as an aperture 2 stop.

 - **Contrast** – this setting increases and or decreases image contrast by affecting the mid-tones of the image. Increasing the contrast areas that are mid to dark will darken and areas that are mid to light will become lighter, decreasing does the opposite.

 - **Highlights** – this setting affects the bright areas of an image. Moving to the left darkens the highlights, moving to the right brightens the highlights but minimizes clipping.

- **Shadows** – this setting is for dark areas of the image. Moving to the left will darken shadows and minimize clipping, moving to the right will brighten shadows.

- **Whites** – this setting can correct white clipping, moving to the left will reduce the clipping in highlights and moving to the right will increase highlight clipping.

- **Blacks** – this setting can correct black clipping by moving to the left to increase black clipping and moving to the right will reduce the shadow clipping

- **Blacks** – this setting determines which image values will map to black. Move the slider to the right to increase areas that will be black and it can create an impression that the image contrast was increased. This tool affect the shadows but dose close to nothing to the mid-tones and highlights

- **Recovery** – Recover settings work to reduce extreme highlights and works to change highlight detail lost because of overexposure. If you clip one or two channels, you may be able to recover lost detail in raw image files.

- **Fill Light** – the settings for fill light can lighten the shadows and reveal detail yet still maintain black shades. Over use will create image noise.

- **Brightness** – this setting lets you adjust the brightness of an image, it affects the mid-tones and adjusts the brightness after the exposure is set, after recovery, and after using the black sliders.

Make Global Adjustments to Color:

Adjusting the White Balance

To adjust the white balance in a photo you will use the sliders for white balance in the main toolbar. Choose an area of the photo you consider neutral and click on it, the image white balance will adjust accordingly. Once the adjustment is made you can fine tune it with the sliders.

The temp fine tuners for white balance adjust the temperature of the image. Slide the slider to the left for a cooler temp adjustment, or slide it to the right for a warmer temp adjustment. This tool uses the Kelvin color temperature scale.

The tint fine tuners adjust for a magenta or green tint in the white balance. Move the slider to the left to add green tint to cancel out too much magenta, or slide it to the right to add magenta to cancel out too much green.

Preset white balance can only be used on raw or DNG photos. JPEG and other formats such as TIFF can be adjusted using the sliders only. Temp and Tint adjustment is limited in JPEG type files; it may be a good idea to use raw or DNG if you plan to do a lot of editing to the white balance.

Sharpen and Reduce Noise

The tools you will use to sharpen a photo manually are in the detail panel. These tools will help you make adjustments that can add a touch of professionalism to all your photos.

Amount - adjusts the definition along the edge of images. A value of 0 has no sharpen at all, move the slider to sharpen the image. The lower the value the cleaner the image will be.

Radius - adjusts the size of the area sharpened. The pixels selected along the edge for sharpening is broadened or made less depending on the adjustment of the radius setting. For the best look, use less radius, too much radius can make an image look fake.

Detail - adjusts how much the edges are emphasized by sharpen and how much high frequency information is sharpened. A lower setting is best for removing blur around the edges, a higher setting will sharpen images and make them more pronounced.

Masking - adjusts what parts of the image receive sharpening and how much they receive. With a setting of 0, all areas receive the same amount of sharpening. A setting of 100 restricts sharpening to the edges and areas close to the edges.

Reducing Noise - cleans up artifacts in the grayscale or color of the image that leave the image looking grainy or full of odd color artifacts. Luminance is the noise produced in the grayscale of an image, and Chroma is the noise produced in the color area of an image. Images taken with poor quality cameras and images taken with high ISO speed can produce images with a lot of noise.

On the Noise Reduction area of the Detail panel you can adjust the noise for both the luminance and the Chroma of an image. The first three sliders adjust the noise in the grayscale, this is luminance. The last two sliders adjust the noise in the color area, this is the Chroma.

The luminance slider - adjusts the noise in the grayscale.

The detail slider - adjusts the luminance threshold. Higher values will leave some noise but preserve the details of the photo, lower values will lower the amount of noise but it may blur the details. Shoot for a mix that cleans up just enough without losing too much detail to blur.

The contrast slider - adjusts luminance contrast. Higher levels maintain better contrast, but may add noise blotches. Lower levels provide a smoother image at the cost of contrast.

Color - reduces color noise

Detail - controls the threshold for color noise. Higher levels will preserve the edges of color areas but it can result in color speckles. Lower levels remove color speckles but can produce bleeding of colors

Working with the Histogram

The histogram show you if clipping is occurring in your image. When the histogram shows bleeding off the screen, there is clipping. Clipping occurs when highlights cause dark

shadows, it is basically bad exposure and moving the curves in the histogram can fix some of these problems.

The main reason you may want to use the histogram is for print pictures. All the digital editing you do looks great on the computer screen, but sometimes it is not all that great in print. To produce an awesome print picture, you should know a bit about the histogram.

When you begin working with the histogram open an image in before and after view. Before and after view will help you see the changes you make in real-time so you will now which looks better the before or the after.

Begin adjusting the histogram in small increments and notice how it affects your image. Your main goal is to find and enhance details while lowering the glaring highlights or shadows.

To do this, you will adjust using curves, as you pull each curve, the overall color, tint, hue will change. When you look at the histogram of your image, notice where the histogram begins and ends.

It should stretch across the entire box; this is an image that covers the entire tonal scale. If you image is pushed to one side of the histogram, it is lacking in tonal scale and this can make for a dull image.

Using the slider, you can slide left and right across the histogram of your image and adjust it. The goal is to adjust your histogram to remove any clipping you see. Clipping is the area of the histogram that goes off the chart itself, i.e. it is clipped.

As you adjust with the sliders, pay attention to the image itself, you want the very dark areas to lighten and show some detail, and the bright areas to darken a bit and show detail. You also want to try and remove or at least limit the shadows in the exposure.

Move the sliders for the histogram slowly and do your best to get rid of clipping without extreme movement of the sliders. The colors of in the histogram represent the color scale in the image, if you increase the red on the histogram, it will increase in your image. It takes time to get this perfect but practice will eventually make you a pro.

How to Retouch and Fix Flaws

Camera lens flaws can be fixed or lessened using the tools in the **Lens correction panel.** The following tools will help you correct flaws caused by camera lenses:

- Click manual in the **lens correction panel**. If you want to use auto correct you must be working with a raw or a DGN file. JPEG and other formats such as TIFF cannot use the auto correct features of these tools.

- **Distortion** - can be adjusted by dragging to the left for lines that bend away from the center, this is called Barrel distortion. Correction for lines that bend toward the center can be accomplished by dragging to the right, this type of distortion is called pincushion distortion.

- **Vertical** - adjustment fixes lines to make them vertical. This type of flaw is caused when the camera is angled up or down.

- **Horizontal** - adjustment makes parallel lines horizontal. This type of flaw is caused when the camera is angled left or right.

- **Rotate** - corrects flaws caused by camera tilt.

- **Scale** - adjusts the image size up or down to get rid of empty space.

- **Constrain** - Crop keeps the crop to the image area, this helps eliminate gray border pixels in the finished photo.

While editing your photos you also have the option to edit for artistic effect. Vignette, dehaze, and grain can be used to change the artistic impression of the photo by adding or removing fog or haze, adding graining or creating different types of vignettes.

To use vignettes for artistic effect, choose an option from the post-crop vignette area of the effects panel. You can choose from these three options:

- **Highlight priority** - allows you to recover highlights but it may create color shifts in dark areas of the photo. This is good for photos with bright areas.

- **Color priority** - will minimize color shifts in dark areas of the photo but it cannot recover highlights.

- **Paint overlay -** can mix a cropped image value with black and white pixels but this may result in a flat appearance to the photo.

Once you have chosen an option you can adjust the sliders to fine tune your effect. You can use these tools and sliders to help you make the adjustments you want.

- **Amount** - can lighten or darken the corners of the photo. Negative will darken and positive will lighten.

- **Midpoint** - increases or decreases the area of dark or light created with the **Amount** slider.

- **Roundness** - changes the shape of the vignette; low values create an oval shape and high values create a circular shape.

- **Feather** - will increase or reduce the softening of vignette and on the surrounding pixels. High levels increase the softening and low levels reduce it.

- **Highlights** - control how much highlight contrast is preserved when the Amount is a negative value.

You can also sample the list of presets available in tool bar on the right-hand side of the Module. You can apply different artistic effects and remove them without changing the original photo. Take the time to apply the different effects and see how they change the artistic feel of your photos. Presets are an easy way to make your images unique.

You can simulate film grain for artistic effect quick and easy. Grain can also help mask artifacts in a photo. As you adjust the grain effect, use the zoom control to get in close and see how the adjustment affects the grain. The following tools will change and add grain effects to your photos:

- **Amount** - will control the amount of grain in the image. Dragging to the right will increase the amount of grain.

- **Size** - controls the particle size of each grain. When the size is 25 or more, blue will be added to enhance the effect with noise reduction.

- **Roughness** - will create uniform or uneven grain. Dragging to the left makes the grains more uniform and dragging to the left makes them uneven.

Dehazing will let you increase or decrease the amount of fog or haze in your photograph. Use this effect after you make basic adjustments. Dehaze is found in the effects panel. The

amount of control in dehaze will add haze or fog when it is dragged to the left, when dragged to the right it will remove haze and fog.

Applying Adjustments to other Photos

Once you have created adjustments you can copy and paste them to other photos in your Library.

There are two ways to copy your adjustments:

- In the Develop Module, on the left side of the toolbar is a copy button, click the copy button, click edit, choose settings, copy settings then choose the settings you want to copy.

- In the Library Module click choose photo, develop settings, copy settings, then choose the settings you want and click copy.

There are two ways to paste your adjustments

- In the Develop Module click the paste button then click edit, choose settings, then paste settings.

- In the Library Module, click choose photo, develop settings then click paste settings.

If you want to paste the adjustments to multiple photos, select the photos you want from the available choices and choose photo, then develop settings then paste settings.

To apply Develop presets using the painter tool do the following:

- In the Library Module click the painter tool in the toolbar and click settings.

- Select a Develop preset from the drop-down menu then click or drag across the photos to apply your settings.

- To disable the painter, click on the circle well on the toolbar.

After all of your editing, if you find you are not happy with some of the outcomes, you can undo the image adjustments. This is a great feature, nothing is permanent, the adjustments are saved as metadata that can be applied to any image, and if you remove it from the one you are working on it is gone; without degrading the original photo.

If you have adjusted your picture too much and you are not happy with the results, there are several ways to get rid of the adjustments while you are in develop mode.

These steps will undo adjustments:

- Find and hit the reset button and your photo will revert to the original default settings
- Find and hit the general, zeroed preset and all your settings will be deleted
- Find and select an earlier version of your image from the history panel, or from the snapshots panel that looks like the image before you applied any settings
- Find and slide the individual slider controls to zero
- Find undo in the edit menu, you can hit this as many times as you wish to remove the changes you made

Chapter 6 – Sharing Your Photos

Sharing is easy with Lightroom. You can share your photos on Facebook and flicker or create an online gallery. In the Library Module, there is a Publish Services panel that will help you share your photos. To share with Facebook, Lightroom will establish a connection with your account.

On the left side of the Library module you will see the Publish Services panel. Click the Facebook set up button. Follow the prompts and let Facebook connect with Lightroom.

Now create a collection of your photos to publish on Facebook. Right click or control click; this depends on your operating system. Now you must decide if you want to create a collection or create a smart collection.

Create a collection will allow you to create a collection from your library photos and give the collection a name. Then you can publish your collection to a Facebook album. If you choose create smart collection, you will create a collection based on the rules you choose. Next you will choose a name

for your smart collection then publish to an album on Facebook.

To publish your collection, right click or control click on one of your Facebook collections and click publish now. That's it, now your photos are on Facebook in the album you chose for everyone to enjoy.

If you want to publish your photos on Flickr you will have to set up a connection with your Flickr account. In the Library Module click on publish services, click on Flickr set up and follow the prompts.

You will be prompted to Create Photoset or Create Smart Photoset, choose on and follow the prompts. You will drag your photos from the view panel to the flickr photo set, or photos that match your smart rules will show up in your collection.

How to Create an Online Gallery

At the top of your Lightroom app there is a tab labeled Web Module. This Web Module will help you create a web gallery of your photos online. A gallery uses thumbnails of your photos with a link to a larger image of the photo.

The Web Module has panels on the left side of the page that list templates with previews of how they will look.

The center pane will display your work and panels on the right side have controls for tweaking your layout, modifying the template, adding text and previewing the gallery in your browser.

You will also specify settings for uploading your gallery to a web server.

You will have two choices for creating your gallery. You can create an HTML gallery with thumbnail images and links to larger photos, or a Flash gallery. A Flash gallery uses thumbnails and links along with a slideshow; Adobe Flash player is needed to view this type of gallery.

Select your photos in the Library Module then switch to the Web Module. Your chosen photos are there ready to populate

your gallery. Now just drag your photos and rearrange them the way you want them to appear in your gallery.

On the left side of the Module is a template browser, use the template browser to choose a template for your gallery. Each image you select will give you the option to add titles or captions.

Now you will need to enter your website information. On the right side of the Module is the Site Info panel, fill in the information in this panel. Now add a copyright watermark to your photos.

It is always a good idea to add a watermark copyright when you are putting your photos online; it protects your rights as a photographer.

Add the watermark in the Output Settings panel. In the Output Settings, you can also choose the quality of your large images and add output sharpening.

It is time to preview your web gallery in your browser. In the Web Module in the lower left corner, click preview in browser.

A preview of your web gallery will open in your browser so you can see just how it will look and how it will operate.

Finally, it is time to upload your gallery to the web or export your gallery to a folder on your computer. Open the Upload Settings panel and choose your web server from the FTP server menu, or configure FTP in the dialog box.

You can now save your custom web gallery set up as a template you can use for future galleries. To create a custom web gallery template from your created web gallery, do the following:

- In the Template Browser in the Web Module chose a template to base your custom template on and modify the layout.

- Choose the settings you want in each panel

- Click + in the Template Browser of the Web Module

- Write over the "untitled template" with a name of your choice for the custom template then choose a folder for the template.

Now you can create multiple galleries or change your gallery using the template you customized. This is helpful if you change your site or choose a new server. You will always have your favorite set up without having to create it from scratch each time you want to upload.

Chapter 7 – Lightroom and the Creative Cloud

Although you are a beginner, you will not stay a beginner for long. Soon enough you will realize that your photos are taking over your computer and slowing it down.

This is normal when you love to take photos and live for the perfect shot. Most people head out and purchase an external drive to store all their photos. This is a great idea; it keeps your computer running smooth and all of your photos safe.

An external hard drive may seem like the perfect solution to your picture problem but this too is only temporary. You are not likely to delete any of your photos on purpose to make room on your hard drives; what is going to happen is you are going to continue adding until your run out of space, then you will freak out and look for another solution.

Lightroom and Adobe have that solution worked out for you already, it's called the Creative Cloud Photography Plan. The Creative cloud can handle the storage of all your photos, and the ones you haven't taken yet.

The Creative cloud also gives you access to every photo from every device you have, from anywhere you are! You can even share photos through creative cloud.

Creative Cloud does more than store and share your photos, there are a wide array of apps and plug ins that will bring your creativity to the next level and inspire you to go even further.

The creative cloud photography plan is a must for anyone who is serious about photography, it doesn't matter if you are a beginner or a pro, this cloud is awesome.

Here is a list of the apps and other stuff you can use when you have the creative cloud photography plan.

- You will get the Adobe Lightroom cc app
- Adobe Photoshop cc app
- Adobe photoshop fix
- Adobe Lightroom for mobile
- Adobe Photoshop Mix
- Spark Page
- Spark Post
- Spark Video
- Adobe Portfolio

- Adobe Premier Clip

Although these apps are awesome, the real reason you need the creative cloud is storage. It is safer to keep your precious images in the cloud; if your computer goes down, your work is still intact and waiting for you in the cloud. Creative cloud was created for use with adobe products so it works seamlessly.

Conclusion

Now that you have the skills to use Adobe Lightroom cc your memories will always look professional. Saving photos of important events is now easier and they will never be deleted or lost. Taking photos on vacation is now an exciting experience and you can enhance those photos and share them as you take them!

Everyday snapshots are now works of art that you can display anywhere. Lightroom gives you just what you need to add that extra bit of spark and turn a picture of the ocean into beautiful photo ready for a mat and a frame.

With your new Lightroom skills you will never take a bad photo again because with Lightroom all your photos have the potential to be perfect.

Lightroom is a powerful creative tool, the skills you have learned will help you create online galleries, add flair to emails, and publish a family scrapbook for the entire family to enjoy on Facebook or Flickr. You can print out your own

images on greeting cards and fliers or create or print out your favorite prints for frames.

www.ingramcontent.com/pod-product-compliance
Lightning Source LLC
Chambersburg PA
CBHW060418190526
45169CB00002B/956